Copyright 2019 LIFT. All Rights Reserved.
https://www.liftnibbles.com

This Belongs To:

I Am That I Am

As Above So Below

All Creation Is Vibrating

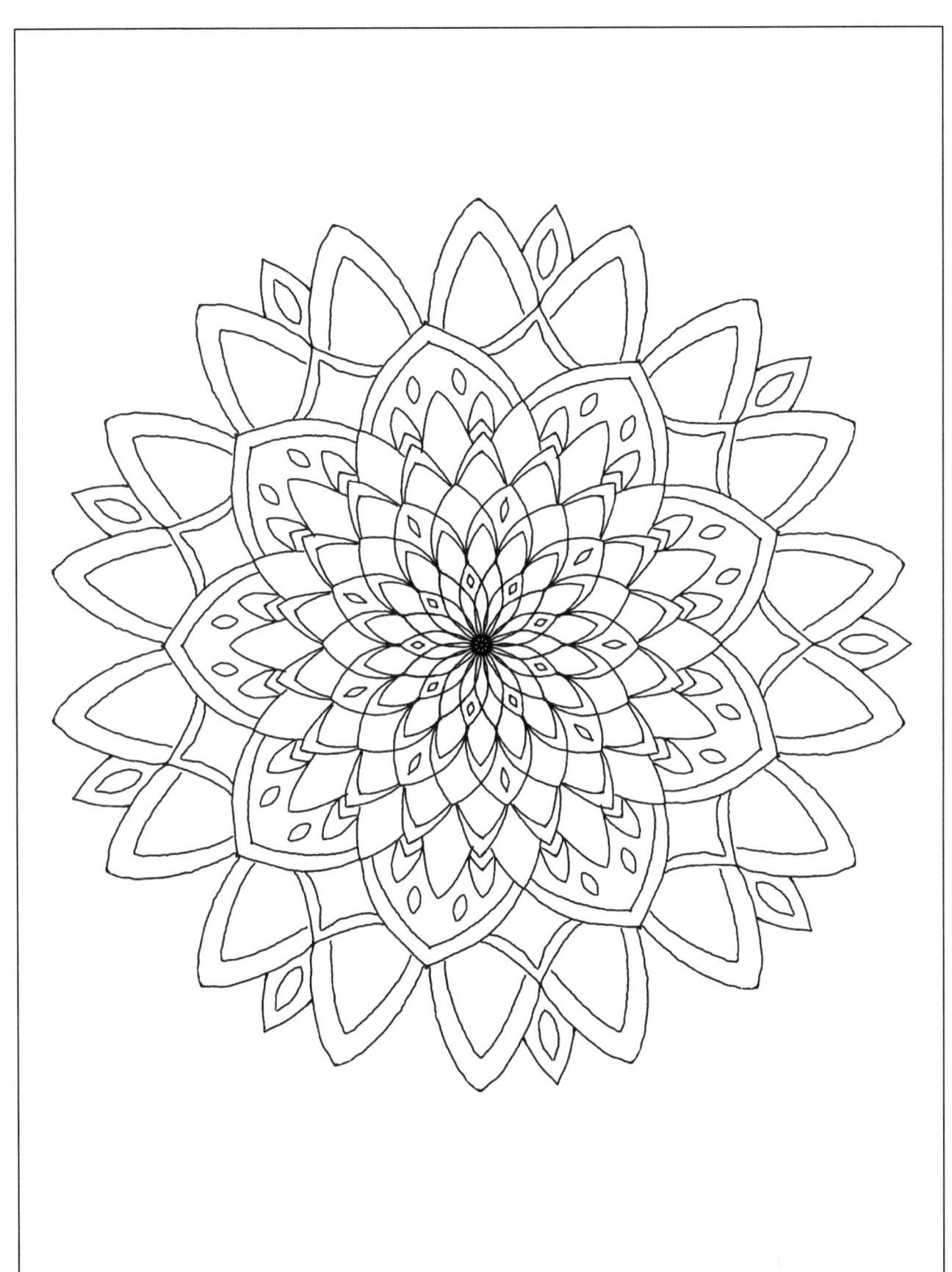

It's Sweet To Be That, For A Little While

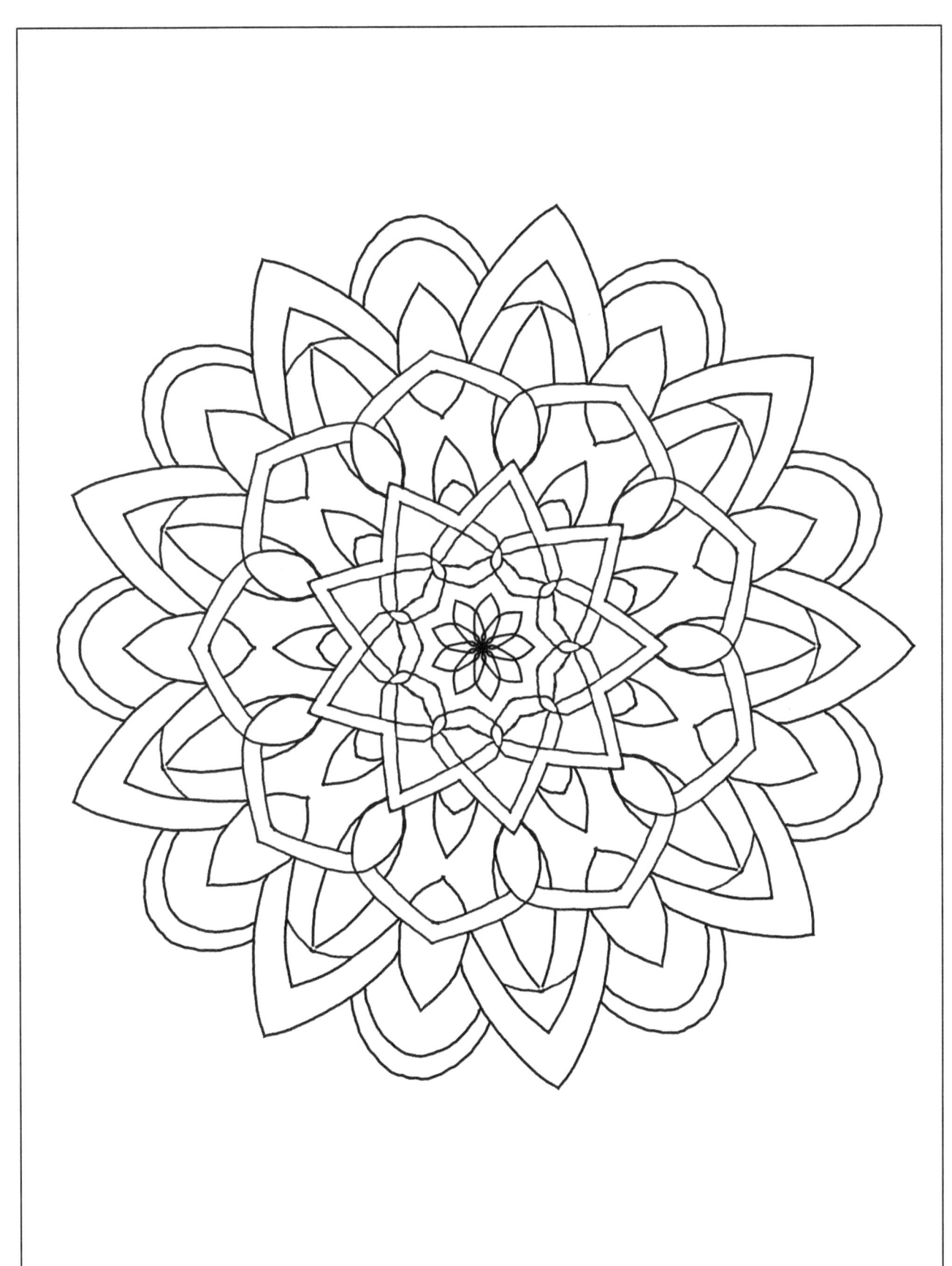

It's OK to Be Imperfect, Beauty.
There's No Failing, Only Learning.

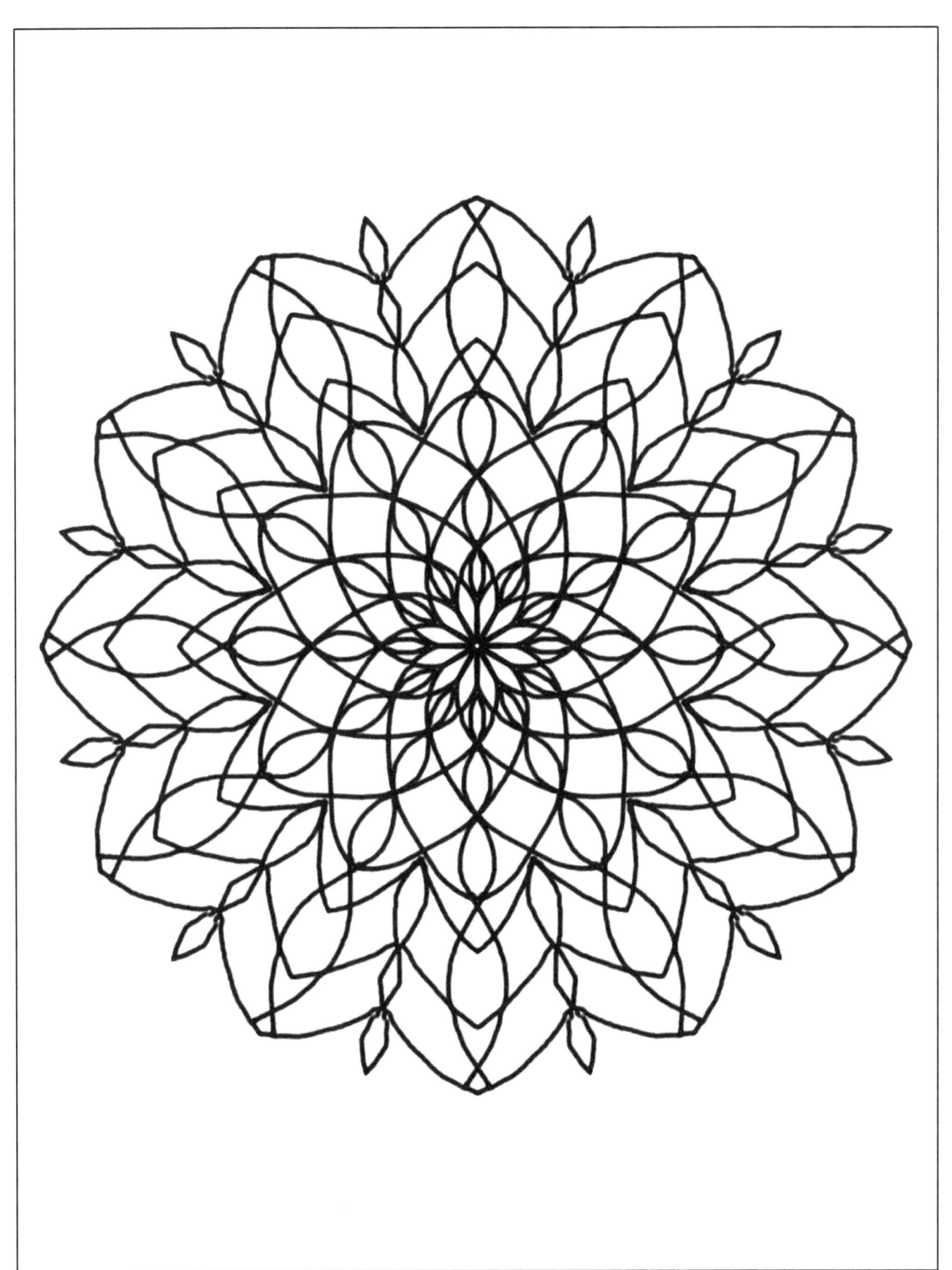

Change Is. So I Am Grateful.

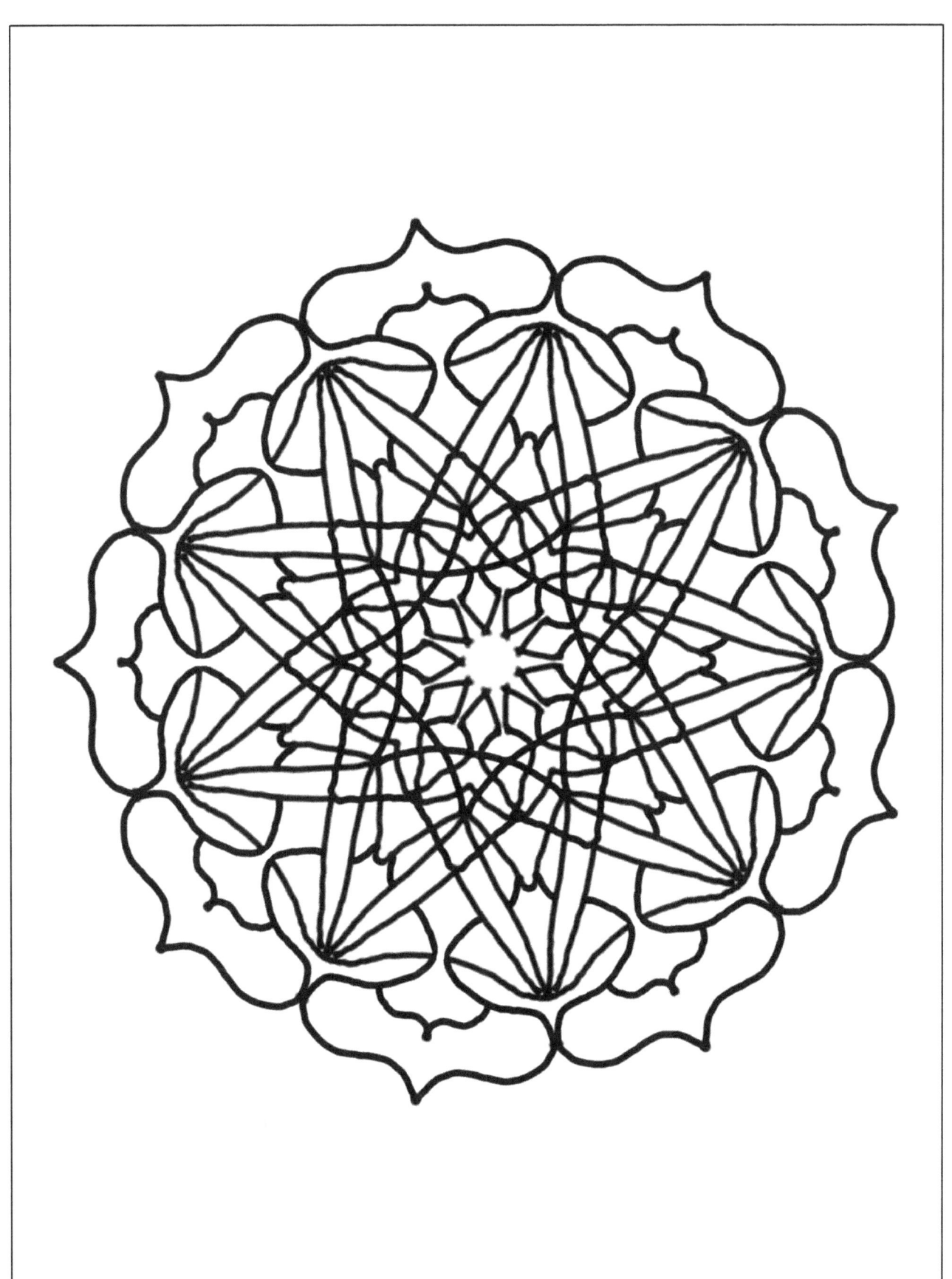

All Actions Want To Feed Innocent Core Values.

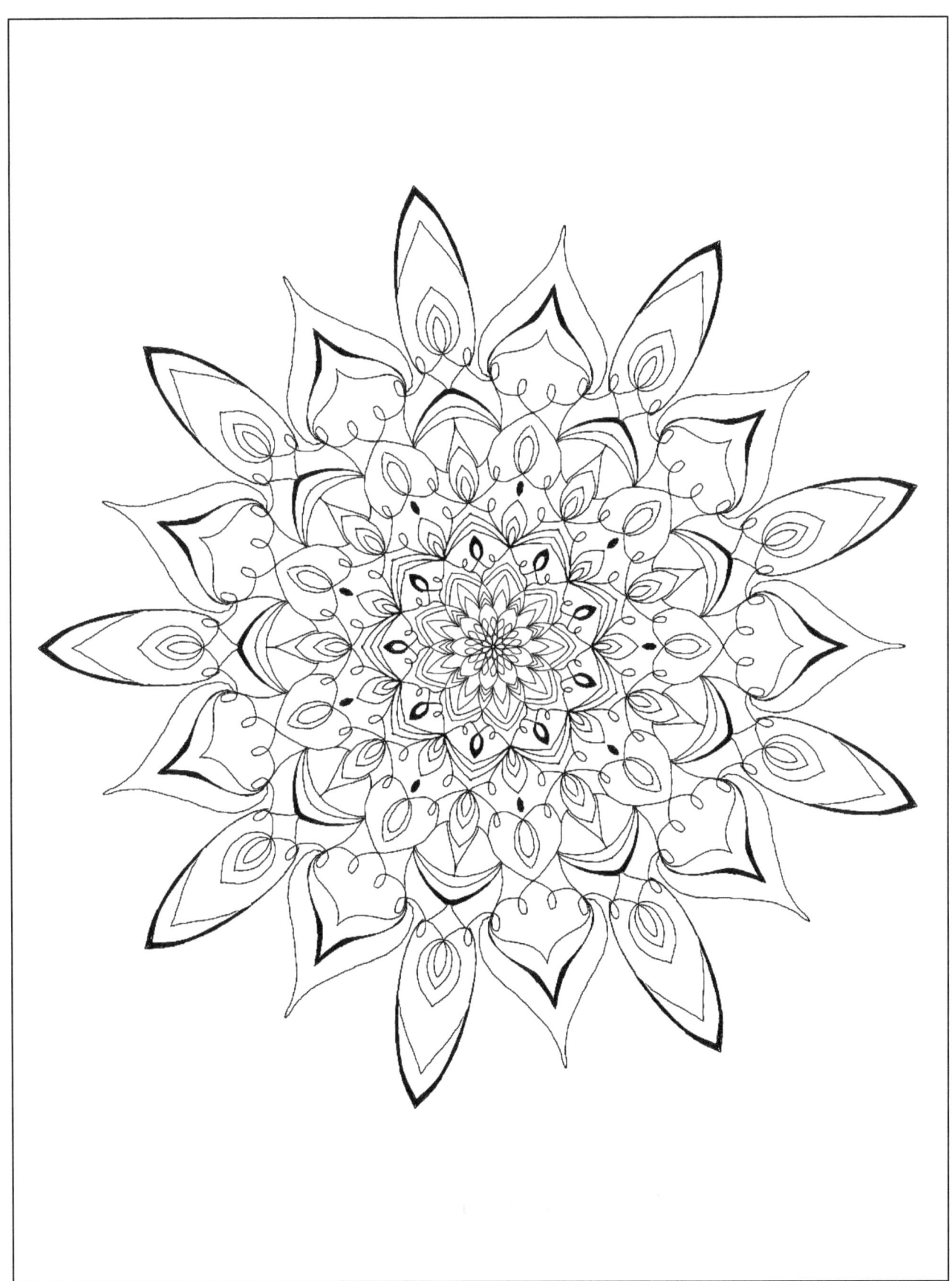

Values Are Faces of Love.

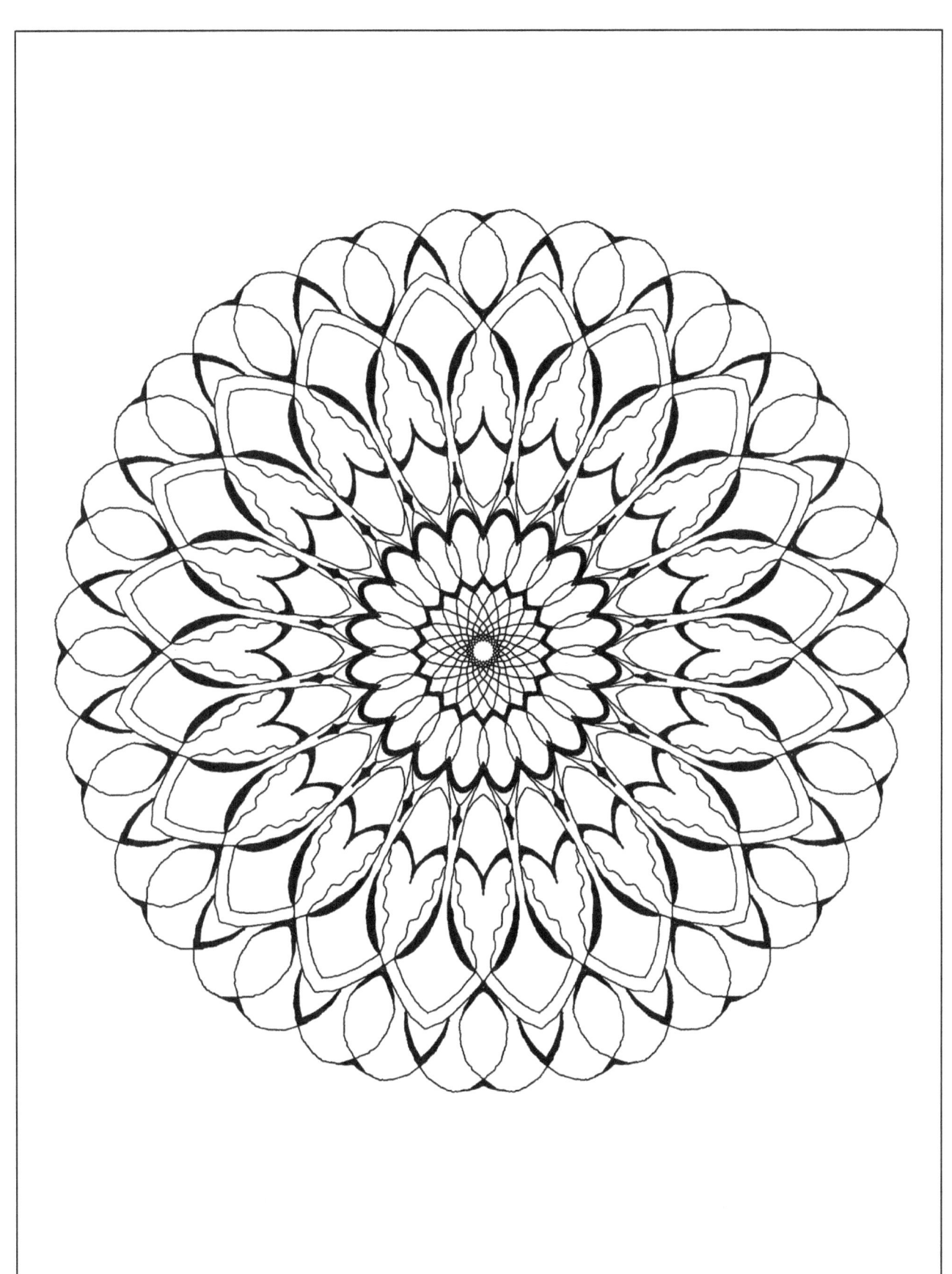

Everyone Is Doing The Best They Can.

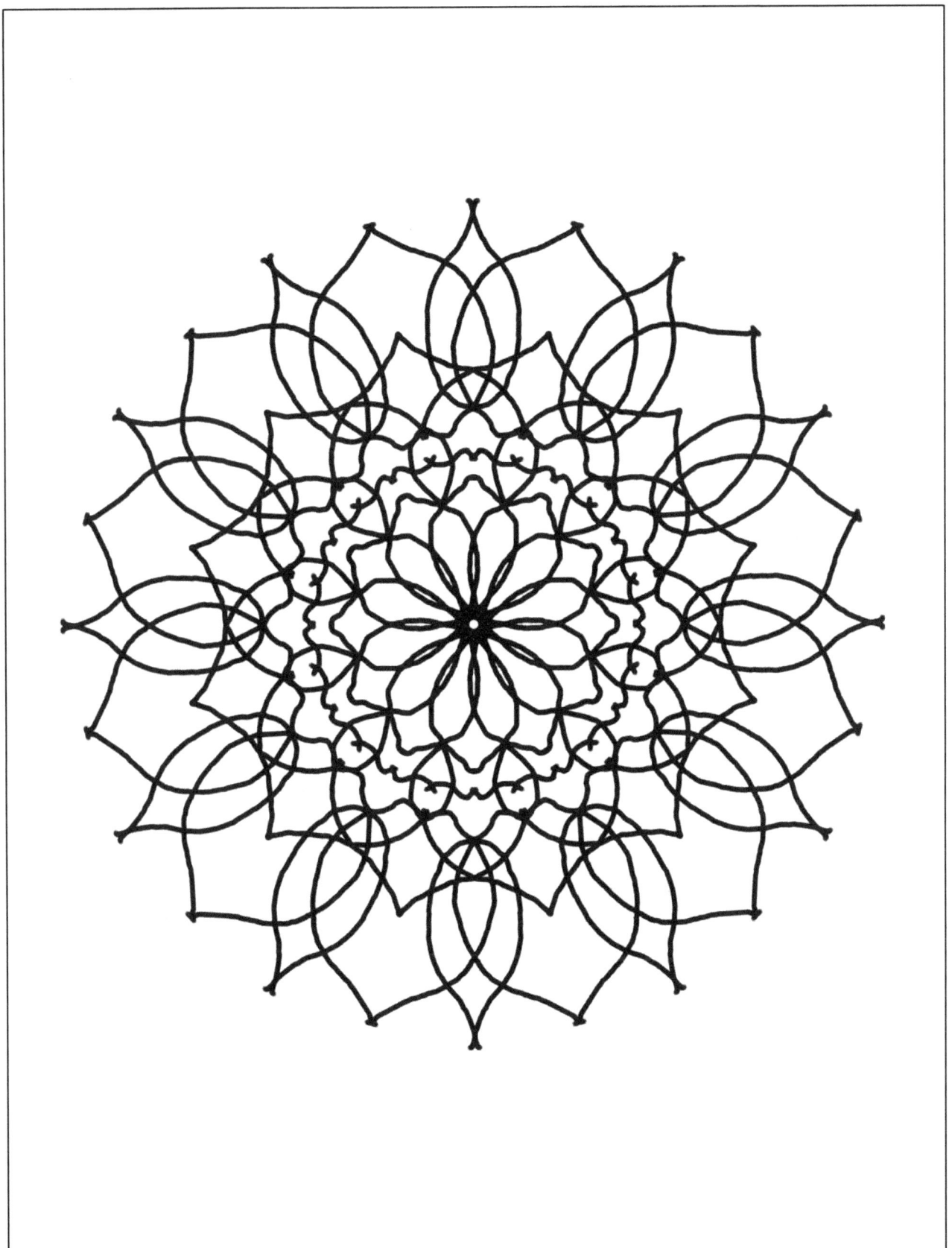

It's OK to Grieve. It's OK to Mourn the Gap.
Grief is a Face Of Love.

All Creation Is Made of Love, including Change.

I Am Immersed In Love.

Sometimes Imperfect Love. Sometimes Broken Love.
But it's Still Love.

All Truths Have Pros and Cons.

Reality Is Multidimensional.

Creation Loves
Taking Experience Beyond Where It Was Before.

Life Is A Smorgasbord.

Sometimes The Hardest Part of Life, is to Live In It.

Like Cleansing Ocean Waves, I Breathe Out the Grief, I Breathe In The Desires.

There Too Am I.

The Slower I Breathe,
The More Dimensions I Perceive

Infinite Stillness Is.

Of Creation. With Creation. As Creation, Creating.
I Am.

Abracadabra.

As I Think, I Experience.

Disposition Shapes Transmission.

What Goes Around, Comes Around.

I Trust Beyond MySelf.

Ultimate We Are Lovingly Held
In The Lap of Creation.

The Universe Surprises and Delights Me.

More and More, I See The Playing
of Creation's Orchestra.

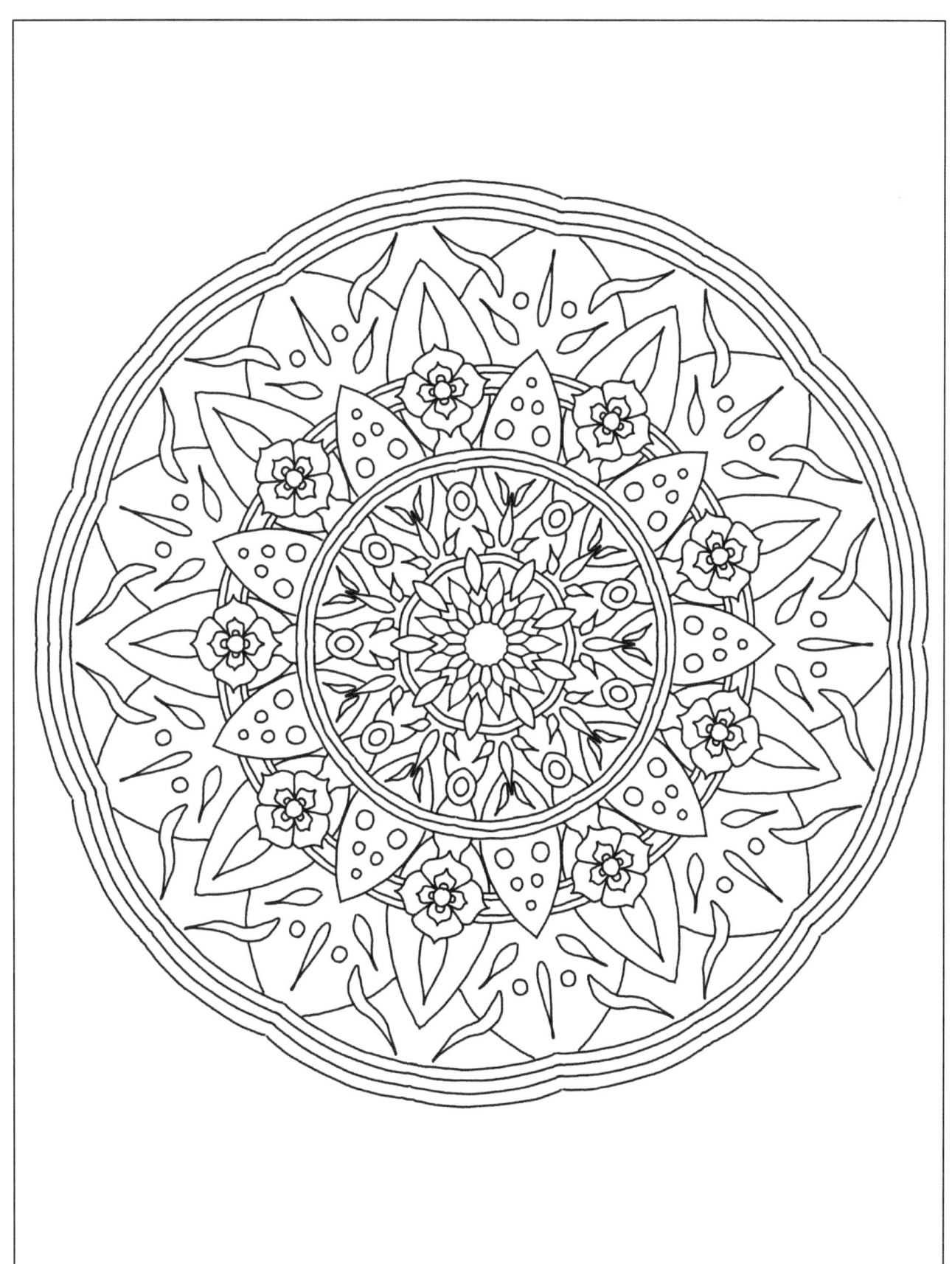

Consciousness Communicates Continuously.

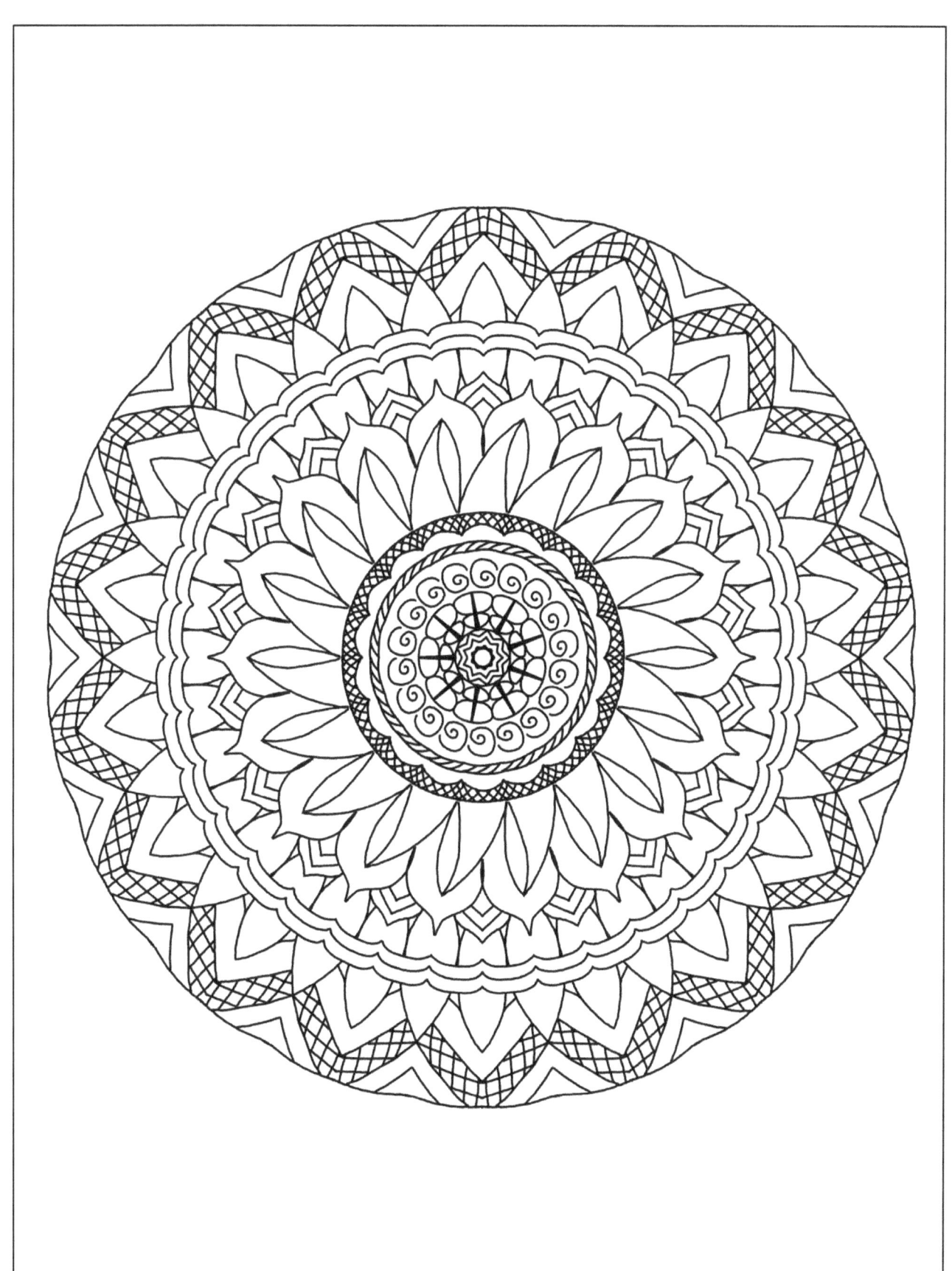

Holographic, Cymatic, Tortoises All The Way Down.

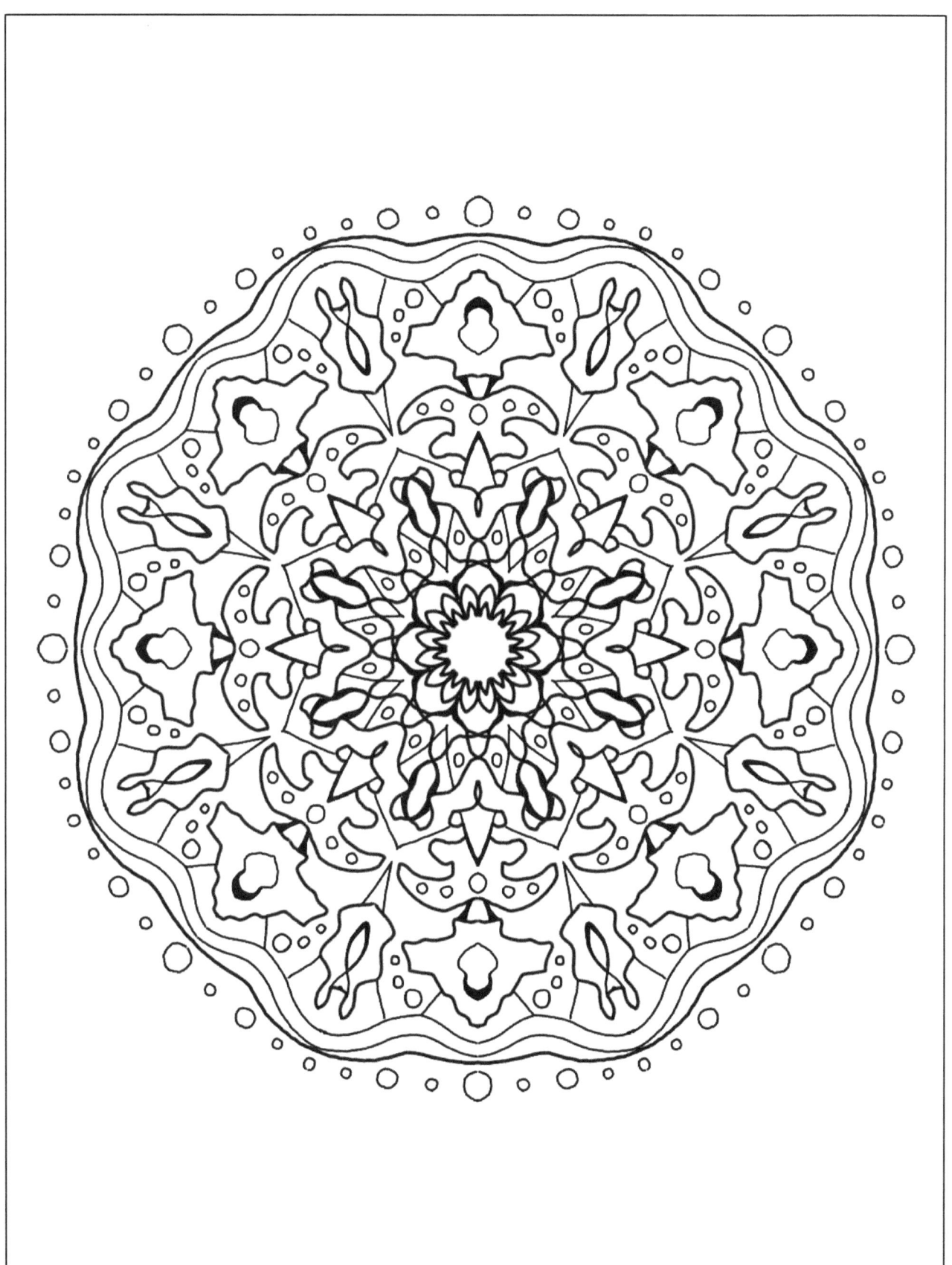

I Am Satisfied.

Why Rush to "Rest In Peace"?

"We Are Only Immortal for a Limited Time."
"Get On With The Fascination." - Rush

I Am Absolutely Involved, I Am Permeable.
I Am One.

www.ingramcontent.com/pod-product-compliance
Lightning Source LLC
Chambersburg PA
CBHW081455220526
45466CB00008B/2651